Moonstone Press

Project Editor: Stephanie Maze
Art Director: Alexandra Littlehales
Senior Editor: Rebecca Barns

PHOTOGRAPHY: Cover: © 2002 William Thompson/National Geographic Image Collection
Back cover: © 2002 Fred Bavendam/Minden Pictures; Beginning with title page: © 2002
Mark Moffett/Minden Pictures; © 2002 Joel Sartore; © 2002 Mitsuaki Iwago/Minden Pictures;
© 2002 William Thompson/National Geographic Image Collection; © 2002 Alan G. Nelson/
Animals Animals; © 2002 Frans Lanting/Minden Pictures; © 2002 Mitsuaki Iwago/Minden
Pictures; © 2002 Frans Lanting/Minden Pictures; © 2002 Fred Bavendam/Minden Pictures;
© 2002 Frans Lanting/Minden Pictures; © 2002 Anup Shah/DRK Photo; © 2002 Steve
Kaufman/DRK Photo; © 2002 Lisa & Mike Husar/DRK Photo; © 2002 Konrad Wothe/
Minden Pictures; © 2002 George Grall/National Geographic Image Collection.

Published in the United States by Moonstone Press,
7820 Oracle Place, Potomac, Maryland 20854

ISBN 0-9707768-3-7
Library of Congress Cataloging-in-Publication Data
Maze, Stephanie.
Amusing moments in the wild : animals and their friends / Stephanie Maze.—1st ed.
p. cm.—(Moments in the wild ; 3)
Summary: Photographs and simple text present a variety of animals in amusing poses
in their natural habitat.
1. Social behavior in animals—Juvenile literature. [1. Animals—Habits and behavior.]
I. Title. II. Series
QL775 .M37 2001
591.56—dc21 2001045288

First edition
10 9 8 7 6 5 4 3 2 1

Printed in Singapore

Amusing Moments

In the Wild

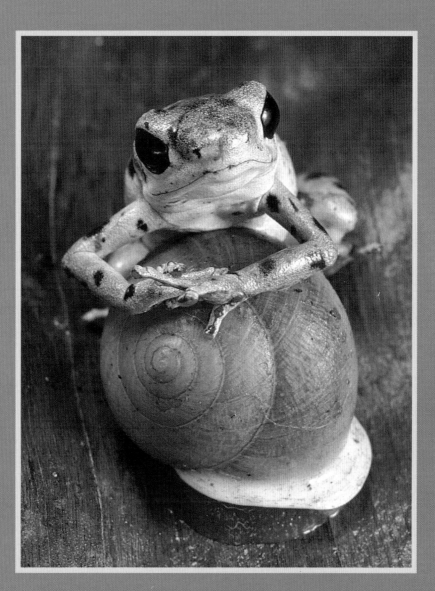

Animals and Their Friends

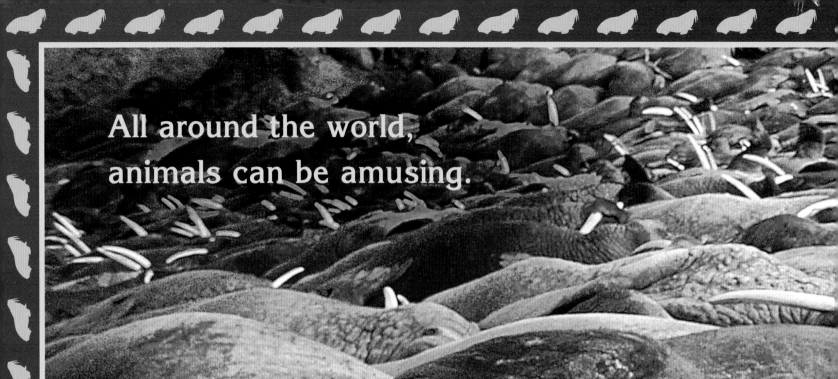

All around the world,
animals can be amusing.

A sleepy **walrus** shields its eyes, playing peek-a-boo with the sun.

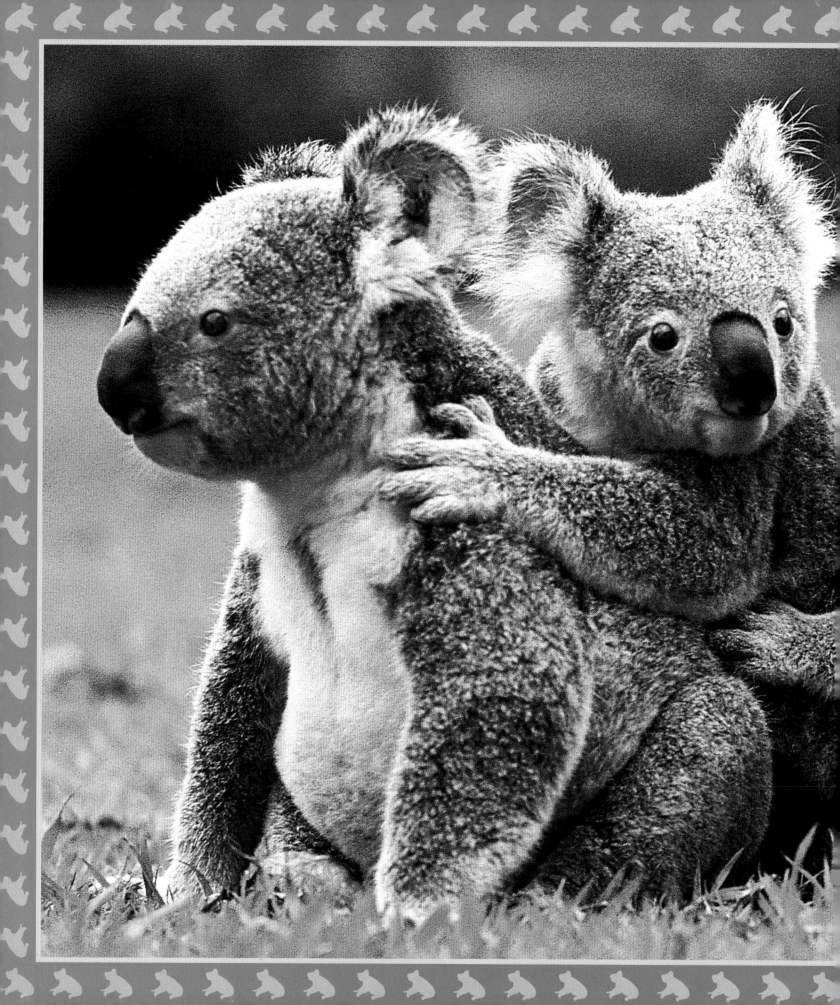

All aboard! These **koalas**
are headed for a day of fun.

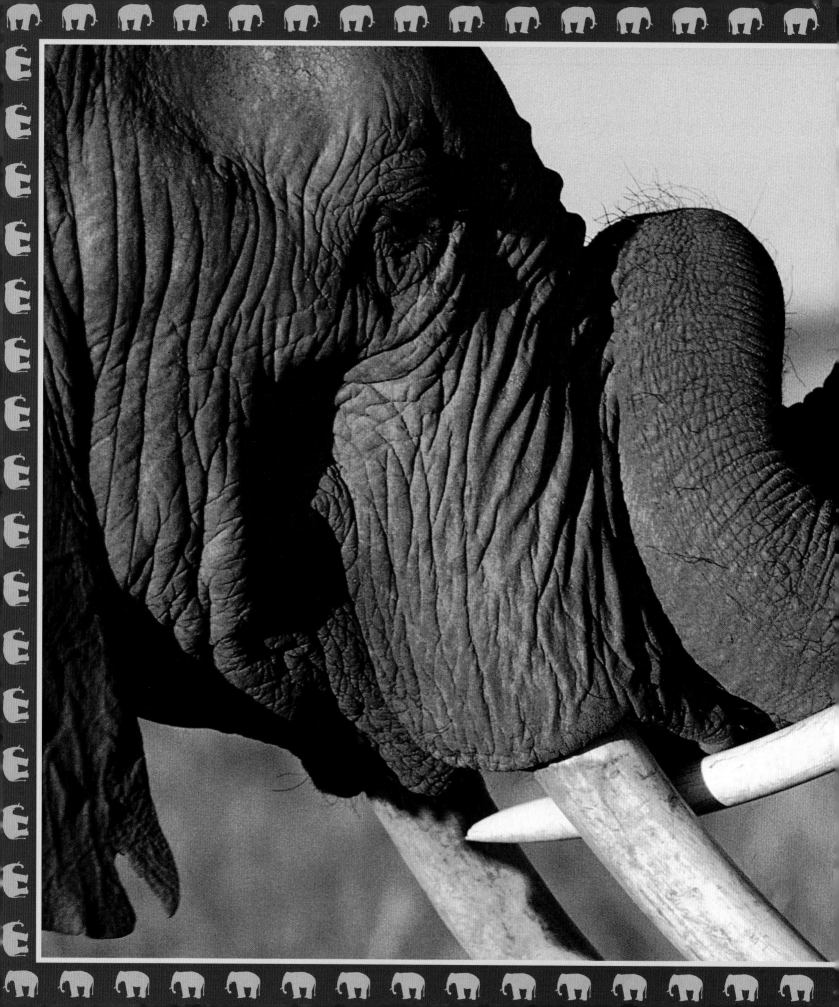

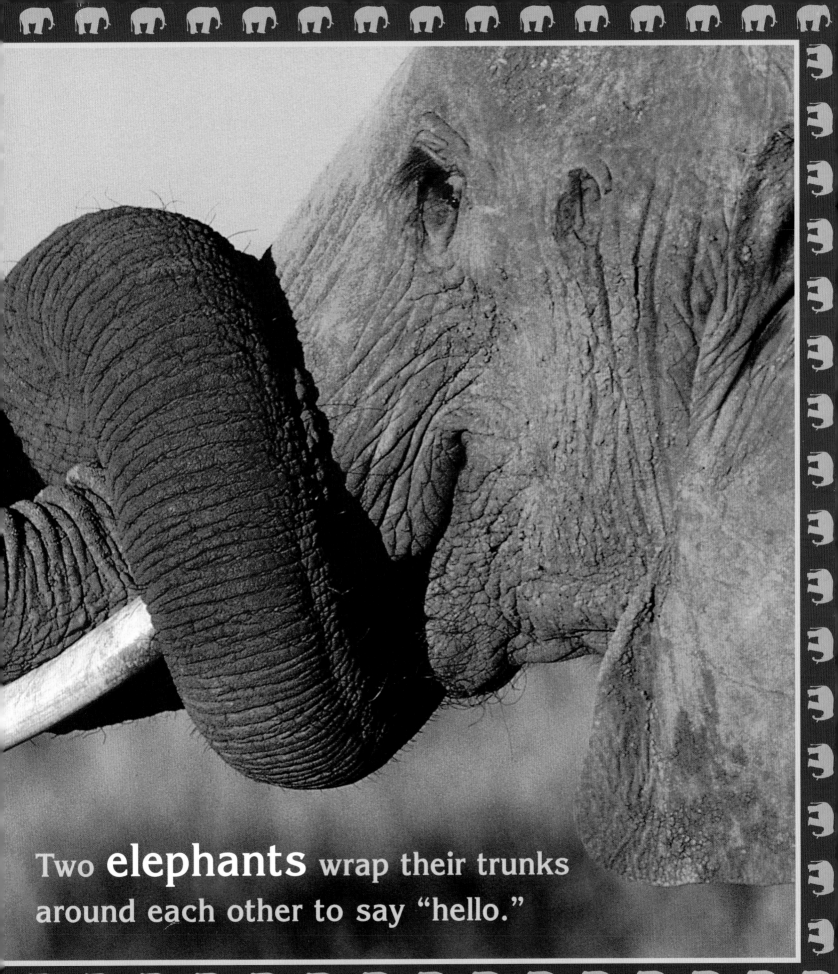

Two **elephants** wrap their trunks around each other to say "hello."

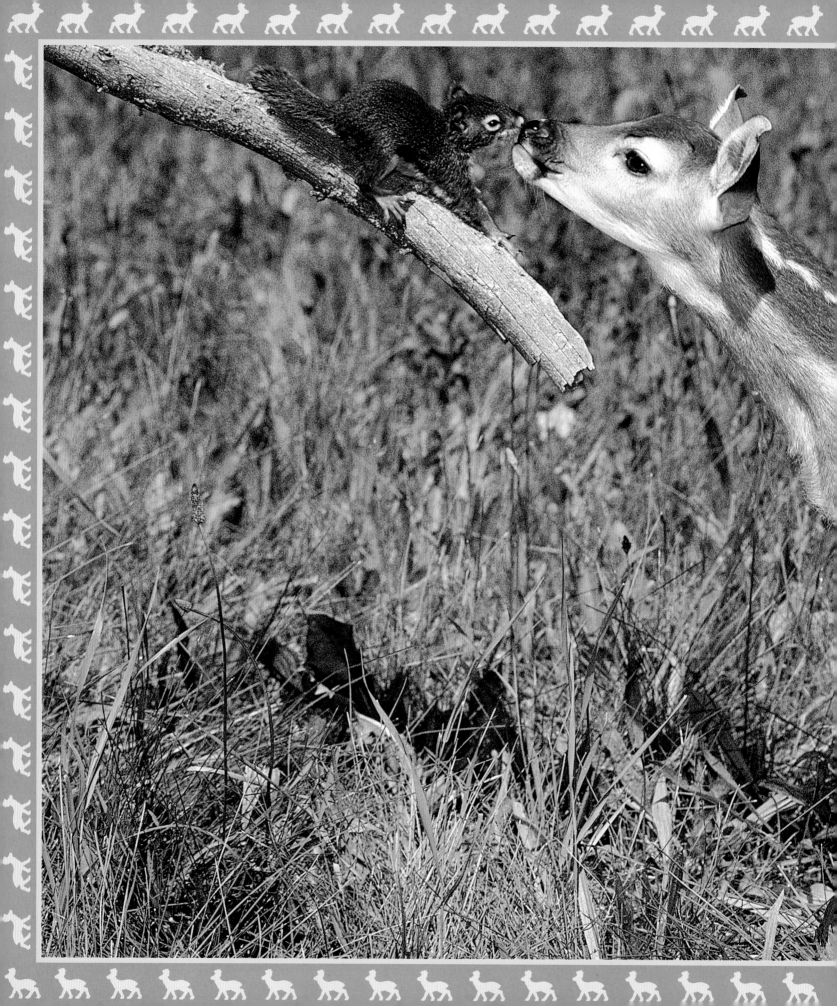

A **fawn** and a young **squirrel** greet each other nose-to-nose.

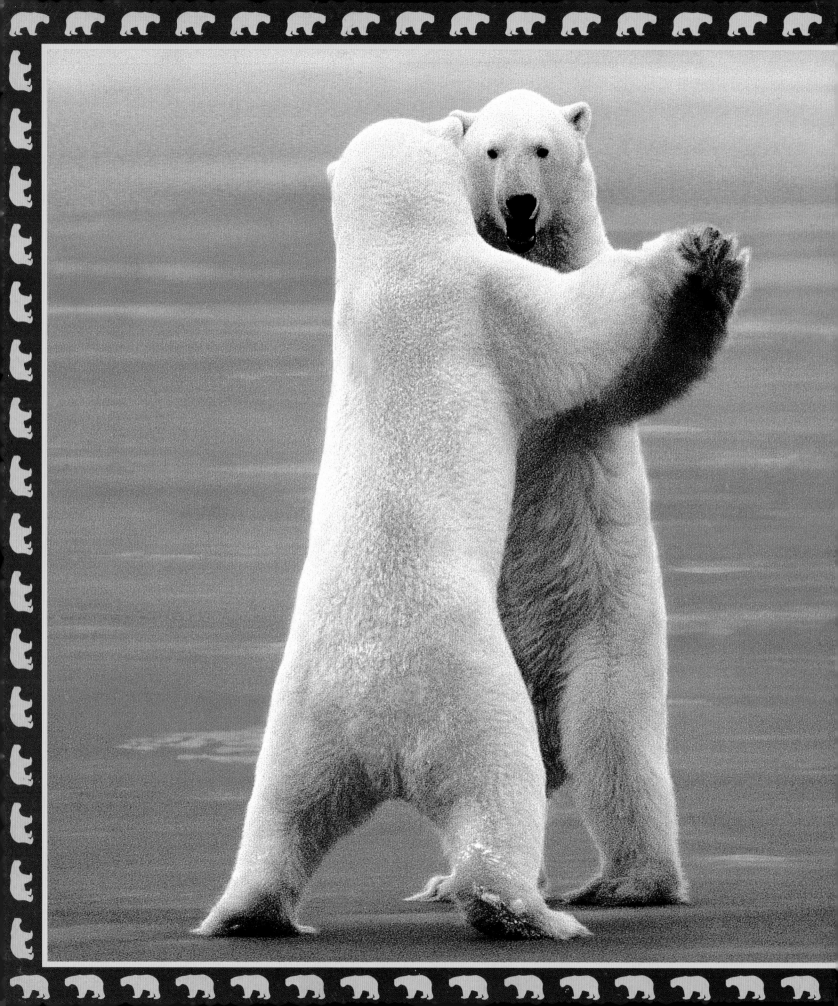

In a battle of strength,
two **polar bears**
dance together on the ice.

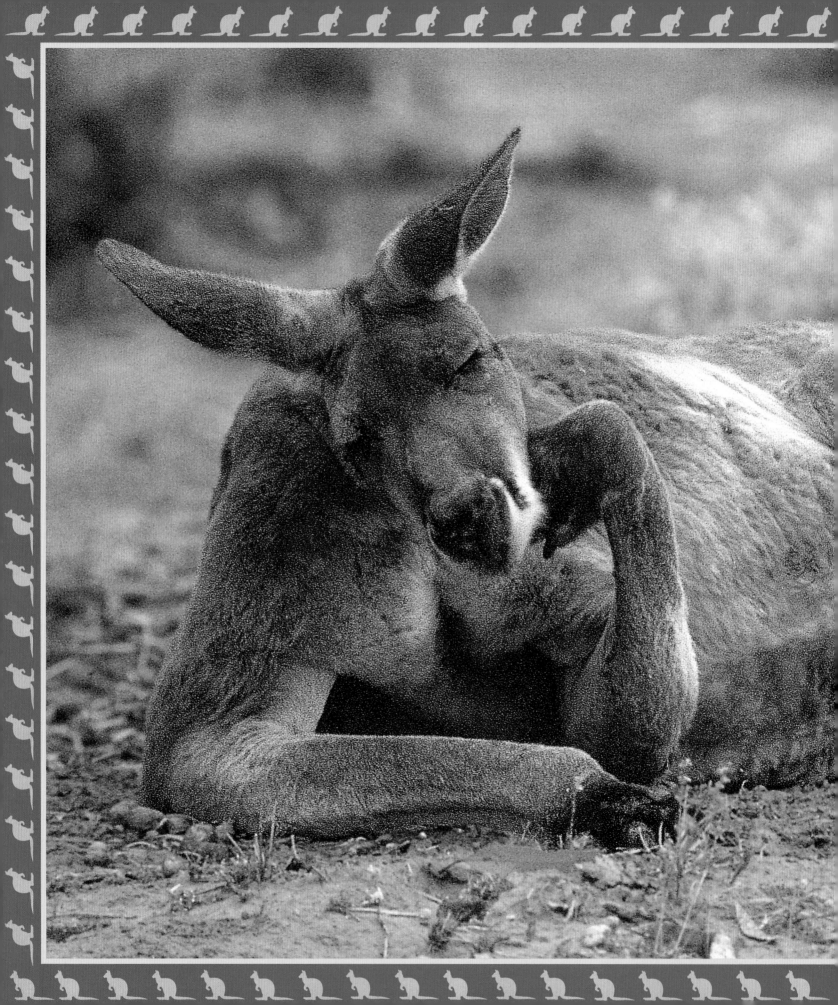

A **kangaroo** stretches out to rest as it ponders its next move.

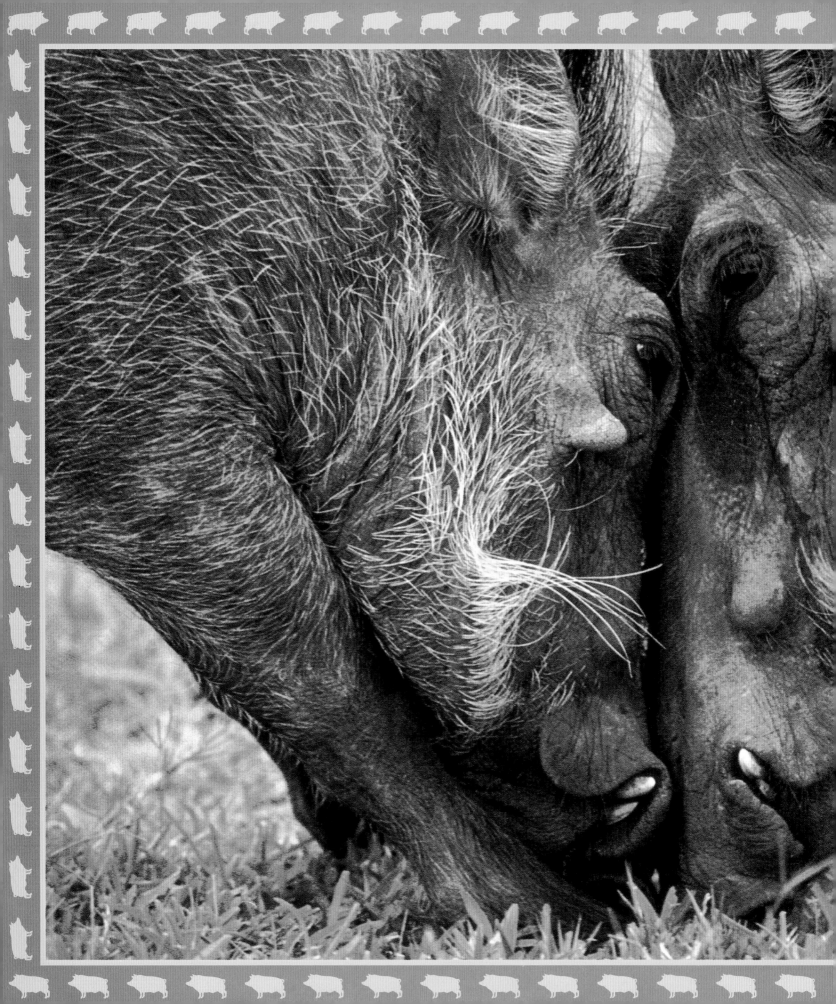

Warthogs butt heads to see who will be the boss.

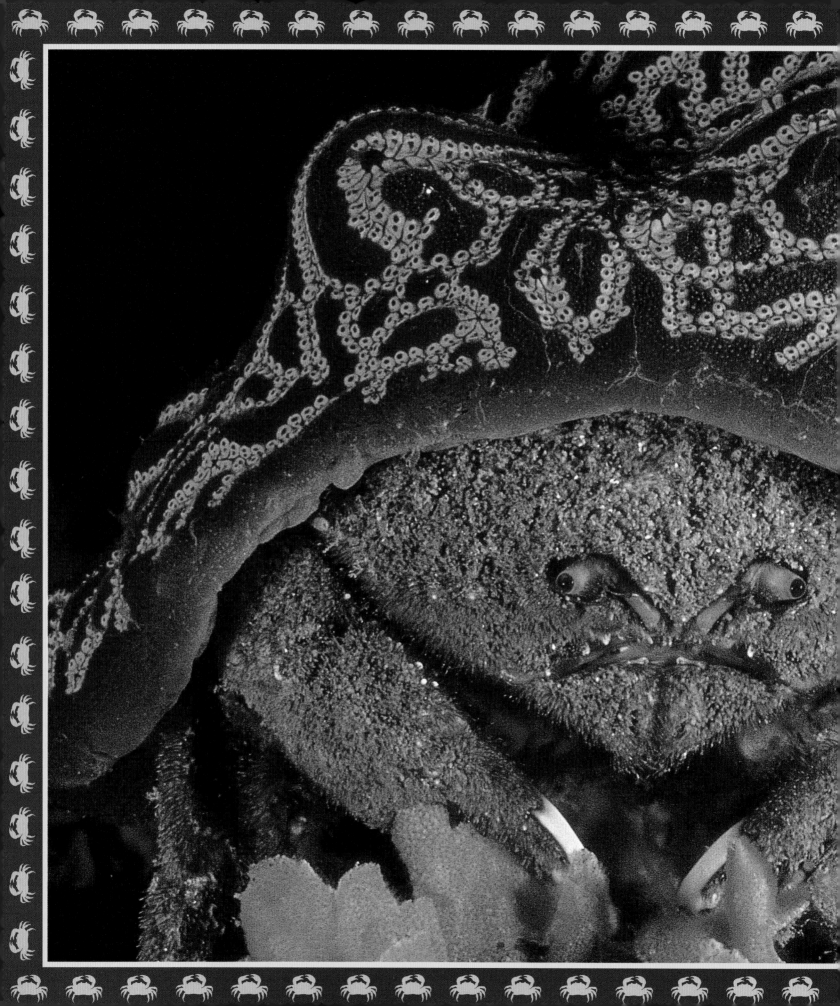

A **sponge crab** wears a fancy seashell hat for protection.

A **chameleon** grabs an unsuspecting bug with its long, sticky tongue.

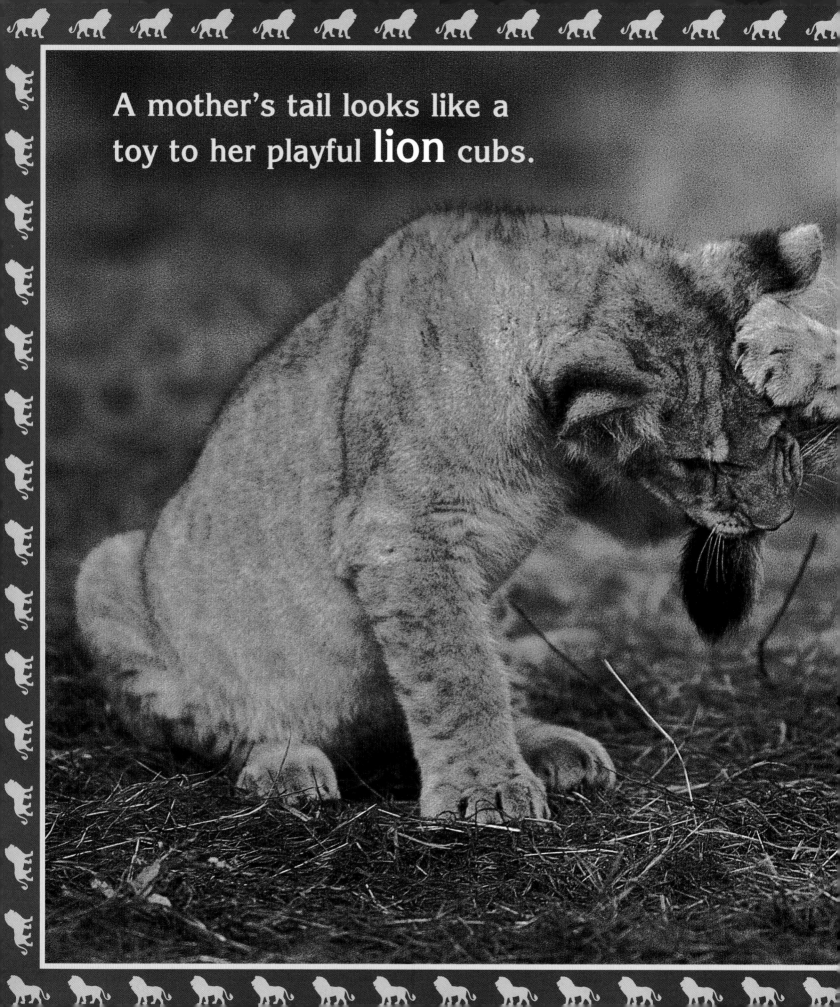

A mother's tail looks like a toy to her playful **lion** cubs.

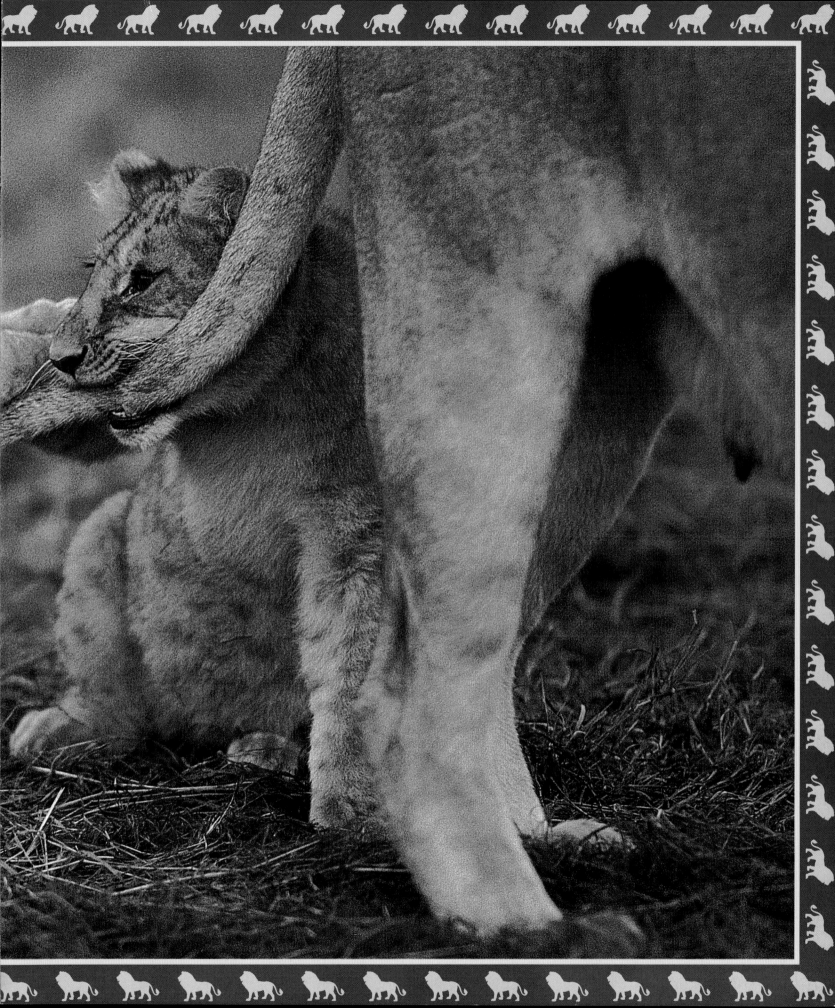

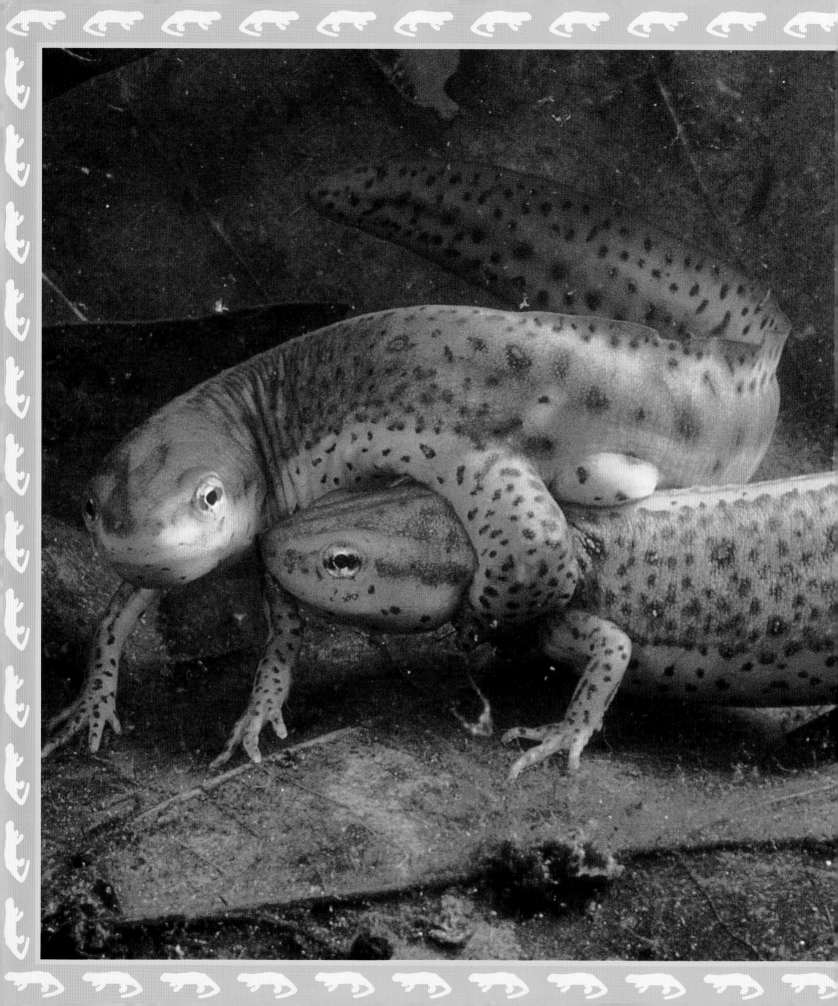

Two **salamanders** wrestle underwater in a playful way.

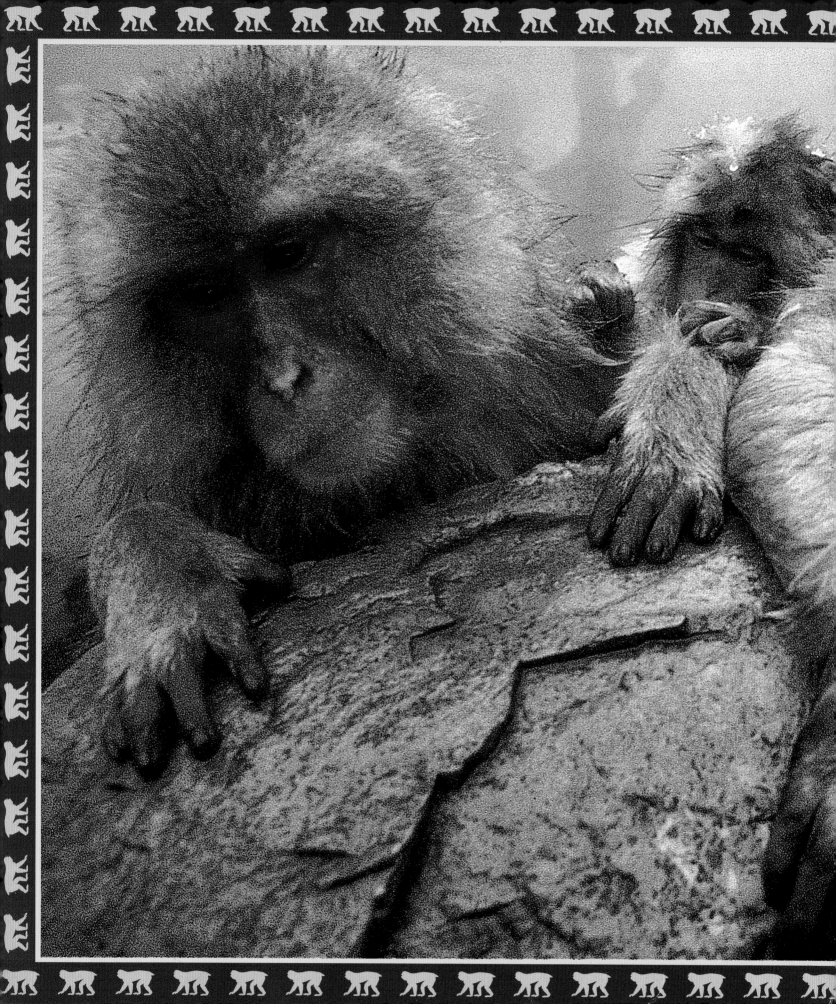

Three **snow monkeys** relax while their friend grooms them.

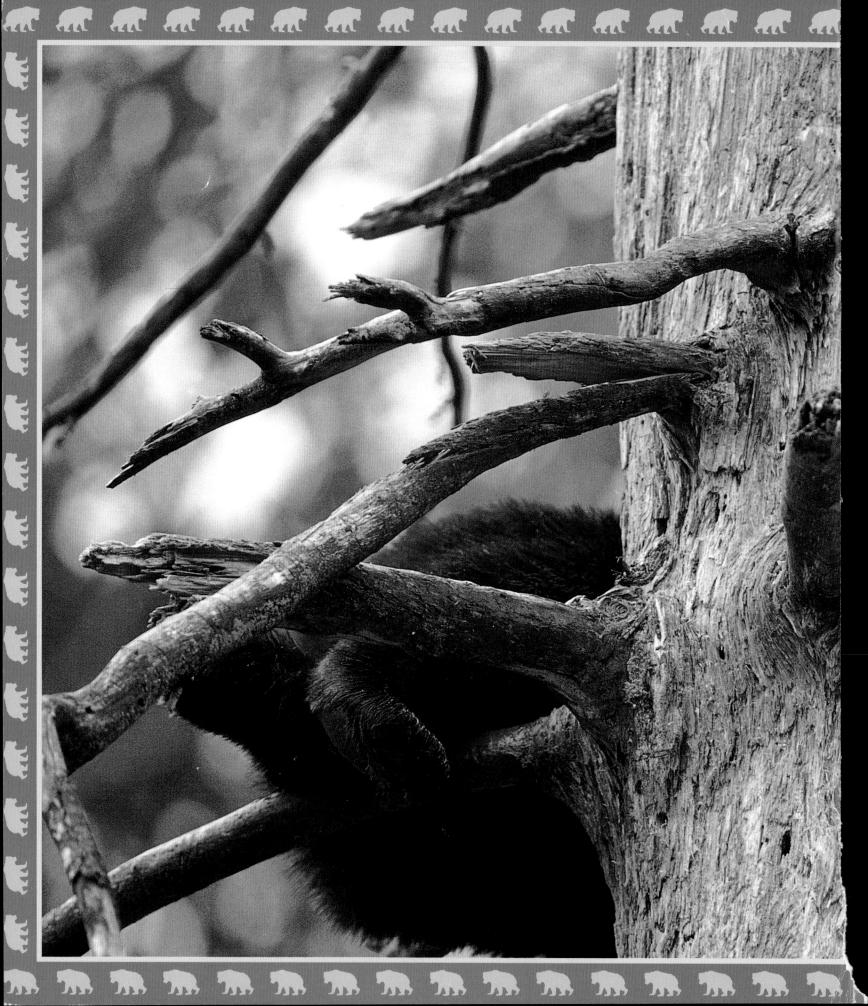

A **black bear** tries his best to snooze high up in a tree.

Two **sea lions** bark loudly
to defend their territory.

All around the world, animals—
even humans—can be amusing!